NEW YORK
JACKIE

NEW YORK
JACKIE
PICTURES FROM HER LIFE IN THE CITY

EDITED BY BRIDGET WATSON PAYNE
INTRODUCTION BY NAN A. TALESE

CHRONICLE BOOKS

SAN FRANCISCO

Library of Congress Cataloging-in-Publication Data available.

ISBN: 978-1-4521-1406-4

Manufactured in China.

Designed by Kristen Hewitt

10 9 8 7 6 5 4 3 2 1

Chronicle Books LLC
680 Second Street
San Francisco, CA 94107

www.chroniclebooks.com

INTRODUCTION

In many ways, Jacqueline Kennedy Onassis was a quintessential New Yorker. In a city that prides itself on style and anonymity for those who seek it, Jackie had both.

No matter how casual the event, she was always appropriately dressed, never overdressed nor wearing conspicuous jewelry—except of course on black-tie occasions. When she lived on Fifth Avenue and worked as an editor at Doubleday, she would walk through Central Park on her way to the office wearing a silk scarf on her head and large sunglasses, wishing not to be noticed. She loved the Park and ran around the reservoir, as so many other New Yorkers did, bicycled with her children there, and took long walks enjoying its beauty. People respected her privacy and (except for certain photographers) did not invade it. One day in the elevator at Doubleday, a fellow passenger looked at her and exclaimed "You are Jackie Onassis." Without a beat, she responded "No I'm not." This was typical of her. And she had a brilliant, and rather wicked, sense of humor.

Although we did not actually meet until the '70s we shared a kind of New York social life when we were younger that was both great fun and old-fashioned. That is, it would be considered old-fashioned by today's teenagers: dancing school, Friday and Saturday nights at La Rue, the Stork Club, or La Maisonette, where we would wear white gloves and dance with swains who always wore ties and usually suits. The Stork Club was indeed like a club where girls took their coats upstairs to Miss Mary's domain and she would tell us which of our friends were there and make sure we looked all right before going downstairs to meet our young men. I think, after World War II we were fairly protected from the tragedies of the world, so unlike today when the headlines scream death, war abroad, shootings, and corruption.

But it was in the '70s that the importance of Jackie as a New Yorker reached its height. We know her pride in the history of the United States led her to renovate the White House, during her husband's presidency. She also chose the Temple of Dendur when the Greek government offered treasures to the American president, and later she saw it installed in the Metropolitan Museum of Art, across from where she would eventually live. On January 21, 1975 she telephoned the Municipal Art Society saying that the State Supreme Court had not allowed Grand Central Station to be designated as a landmark. Her fight to preserve Grand Central was successful and New Yorkers to this day are both grateful and aware that it was she who saved it.

It was only in matters of consequence that she let her "celebrity" serve causes she believed in. Otherwise, her work as an editor at Double-day was like that of many other editors. She dressed plainly, wore

low-heeled shoes and was most often seen in well-tailored pants and a T-shirt of cotton or wool. She stood on line with others if she wanted to see the president of the company about a book acquisition and was mindful of the importance of authors and tried to be sure her presence did not distract from them.

She loved books all her life and so to be involved with them was also to be absorbed in something meaningful. In fact, the point of our initial meeting was to talk about publishing—but she was first of all a mother—so what we spoke about that day was mainly our children. She was gracious, elegant in the simplest way, and had a style that I will always think of as New York.

Nan A. Talese
New York, 2013

1960s

LEAVING THE COLONY CLUB, 1965

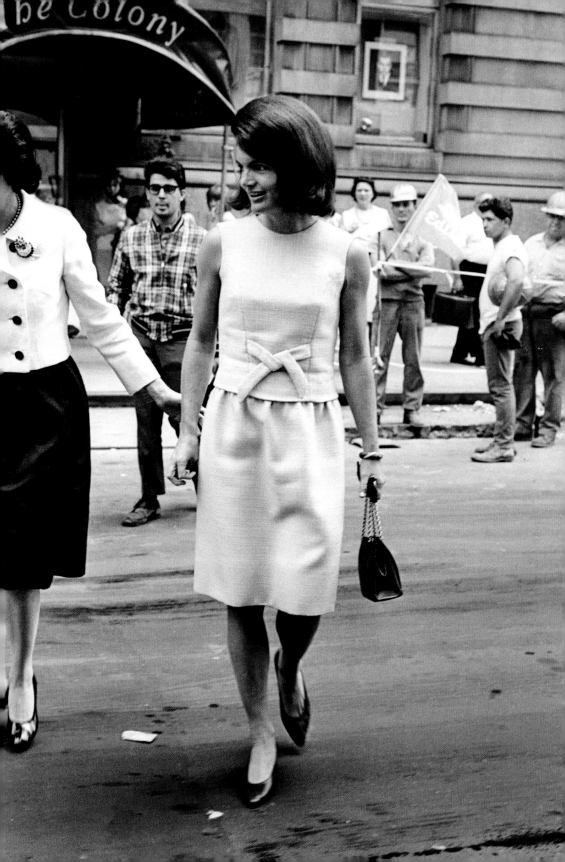

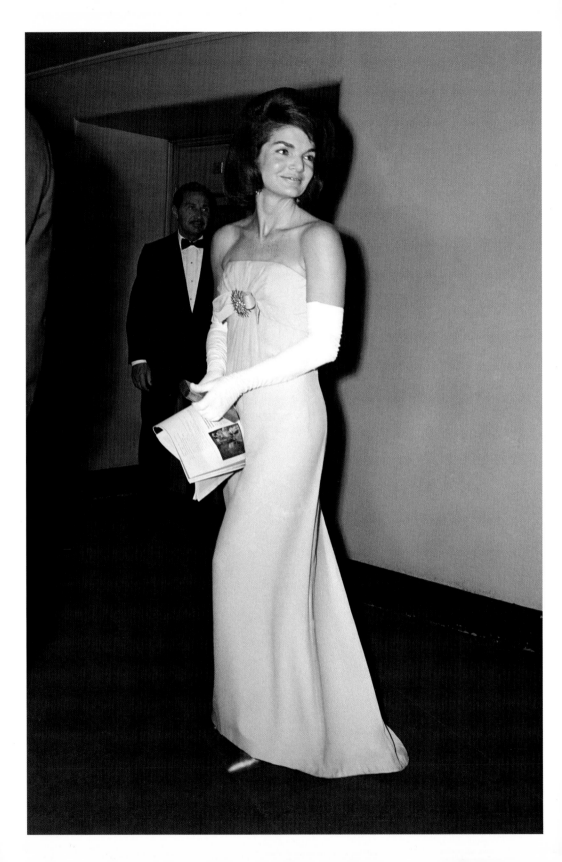

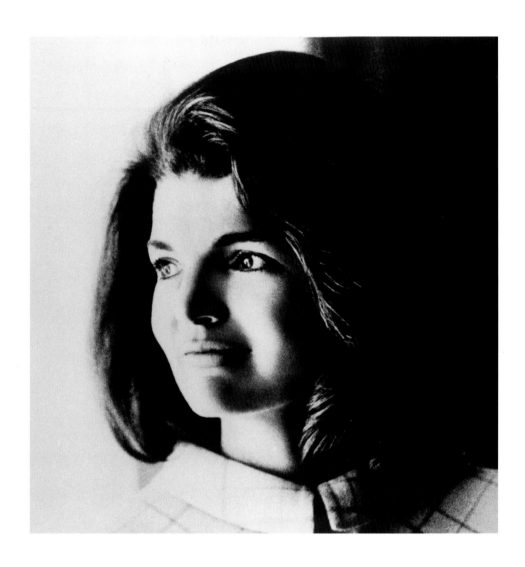

PORTRAIT, 1969

WITH ANOTHER GUEST AND INDIRA GANDHI
AT A PHOTOGRAPHIC EXHIBIT ABOUT THE LIFE
OF HER FATHER JAWAHARLAL NEHRU, 1965

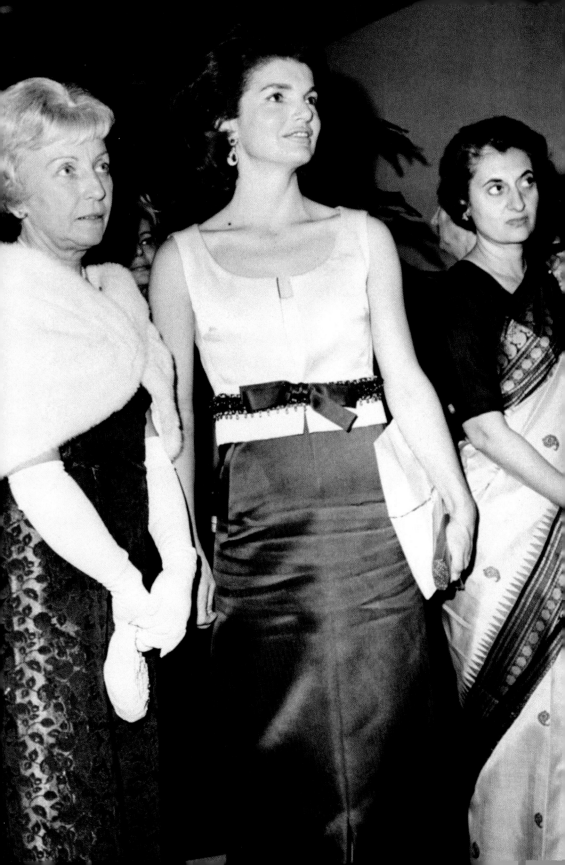

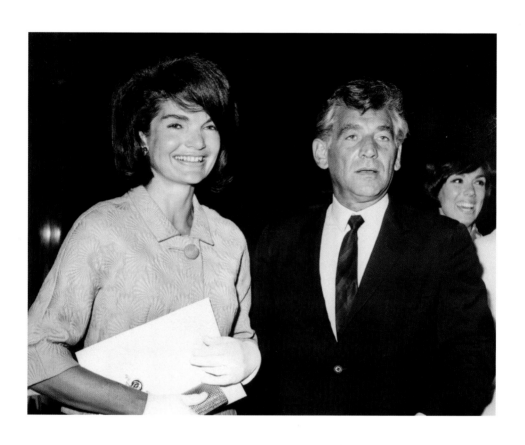

ARRIVING WITH LEONARD BERNSTEIN AT THE GALA
INVITATIONAL PREVIEW OF MARTIN RANSOHOFF'S PLAY
"THE SANDPIPER," STARRING ELIZABETH TAYLOR,
RICHARD BURTON, AND EVA MARIE SAINT, 1965

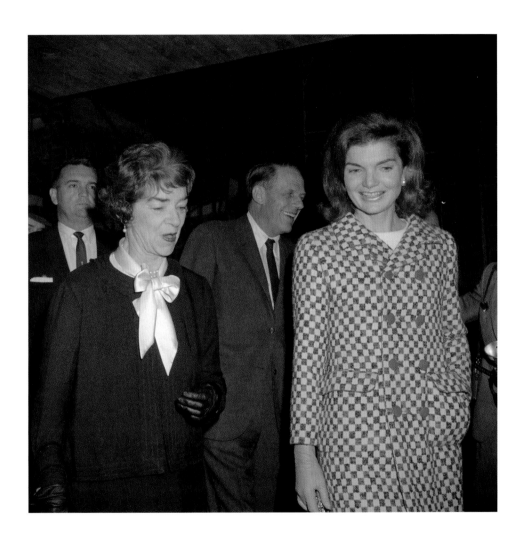

TALKING WITH MRS. FLORA WHITNEY MILLER,
PRESIDENT OF THE WHITNEY MUSEUM, ON A
TOUR OF THE UNFINISHED MUSEUM, 1965

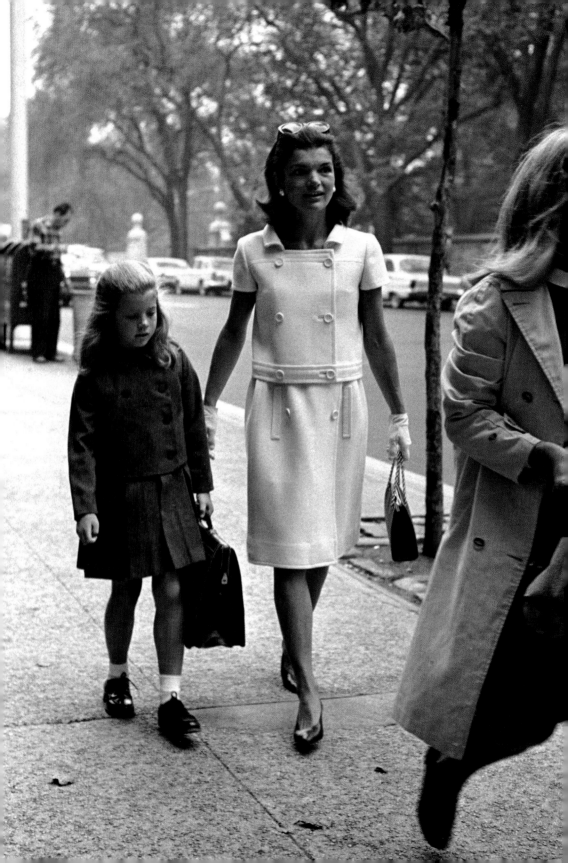

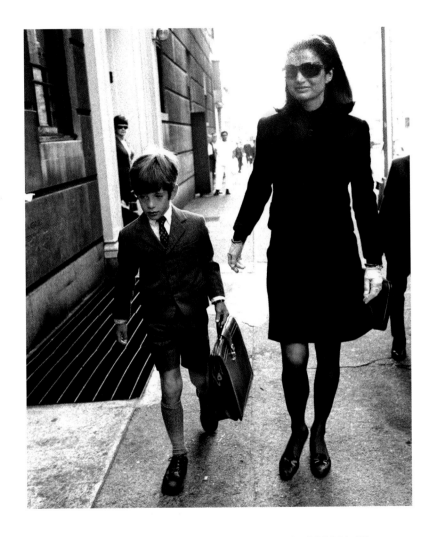

TAKING JOHN JR. TO HIS FIRST DAY OF SCHOOL AT
COLLEGIATE SCHOOL FOR BOYS, 1968

< WALKING WITH CAROLINE DOWN THE SIDEWALK
NEXT TO CENTRAL PARK, 1965

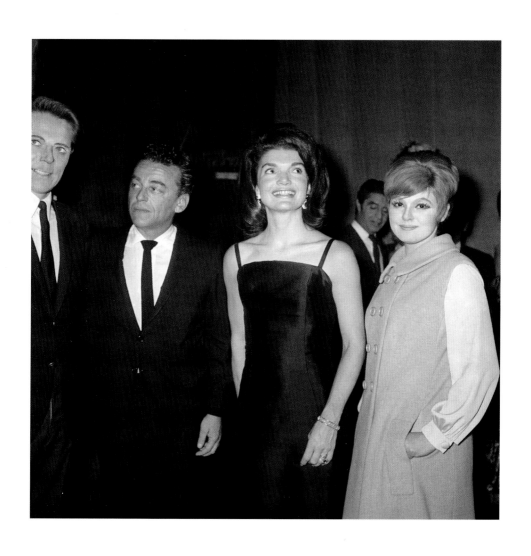

WITH JOHN CULLUM, ALAN JAY LERNER,
AND BARBARA HARRIS, 1965

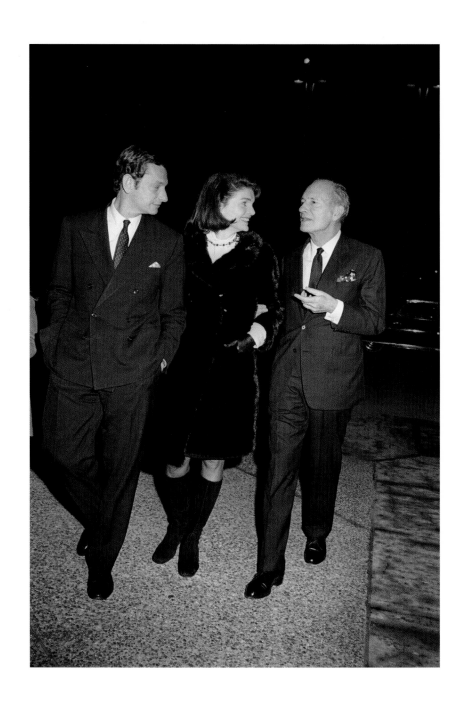

WALKING WITH FRIENDS, 1960s

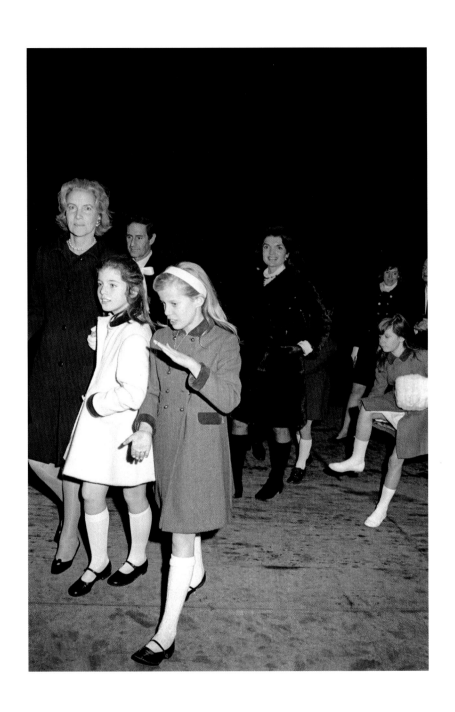

WALKING WITH A FAMILY GROUP, 1960s

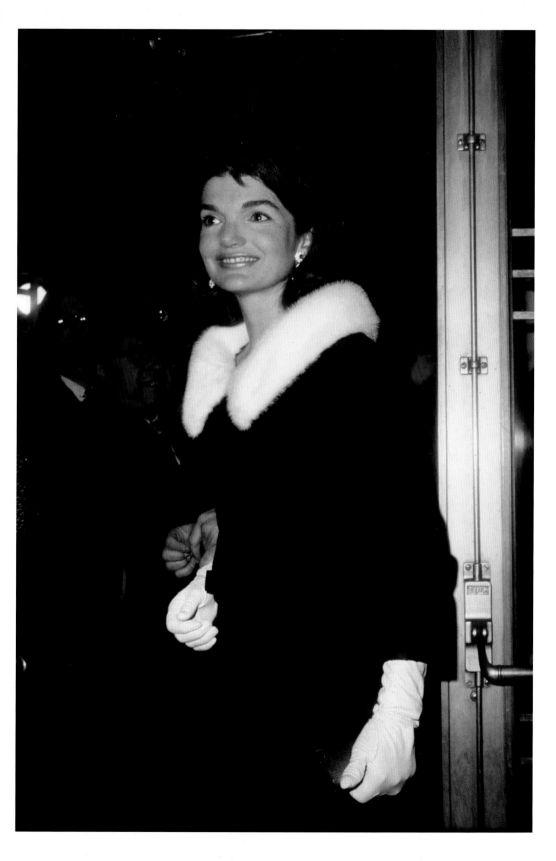

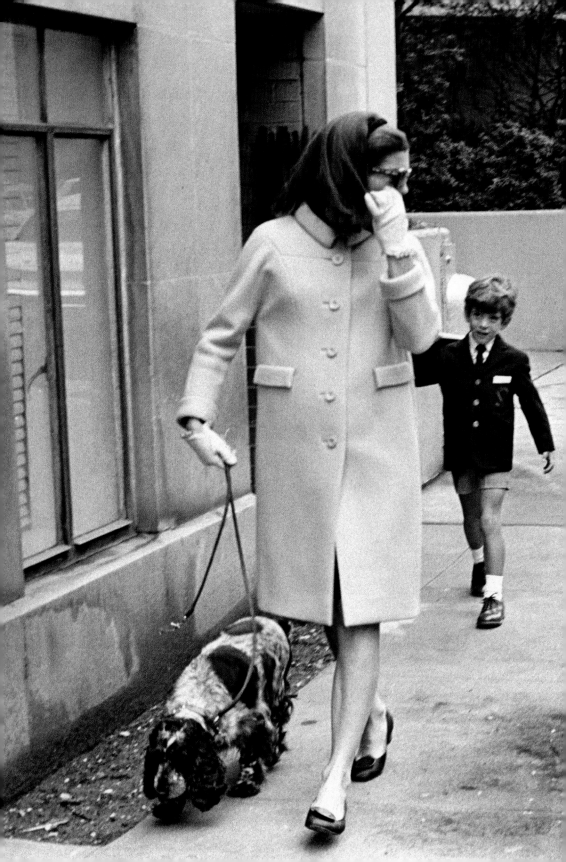

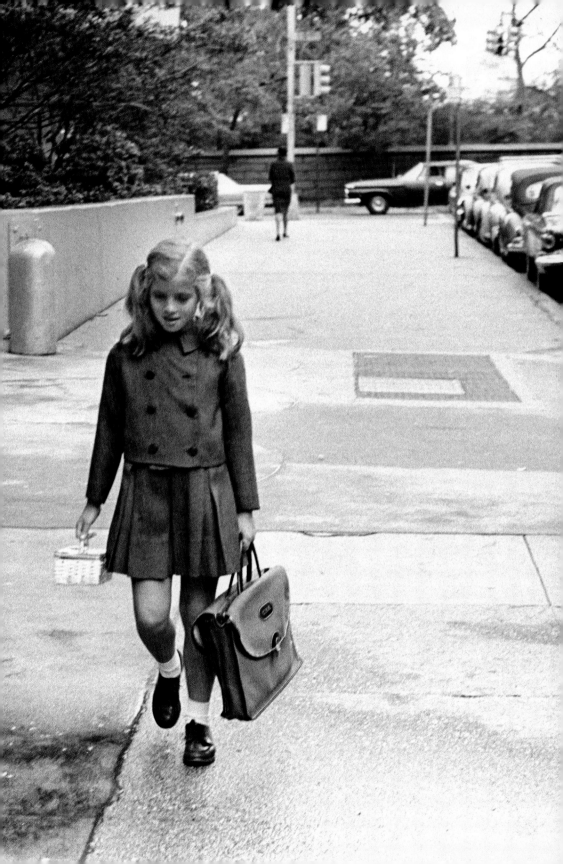

ARRIVING AT JFK AIRPORT TO DEPART
FOR CAMBODIA, 1967

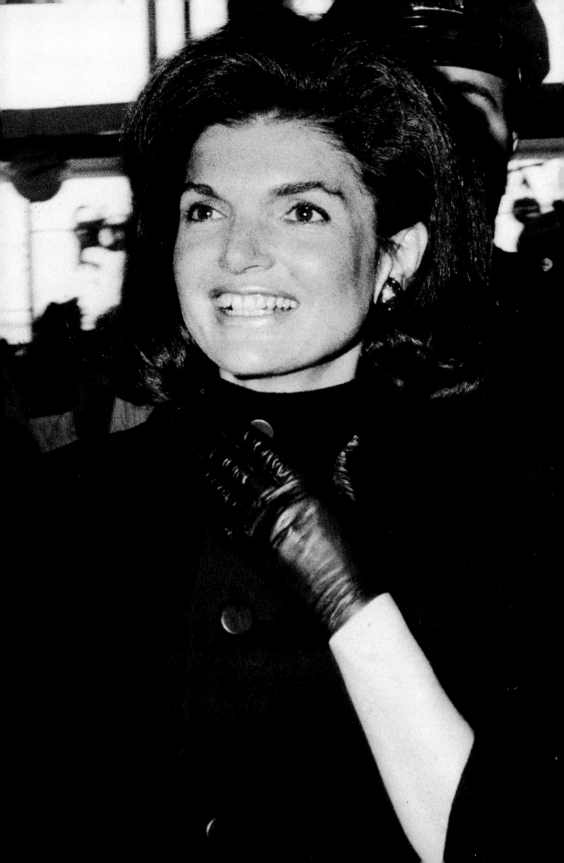

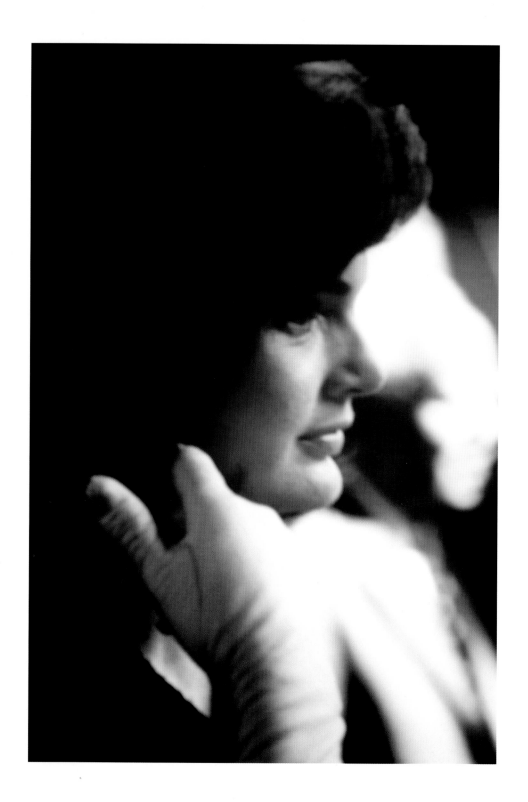

AT LINCOLN CENTER, 1968

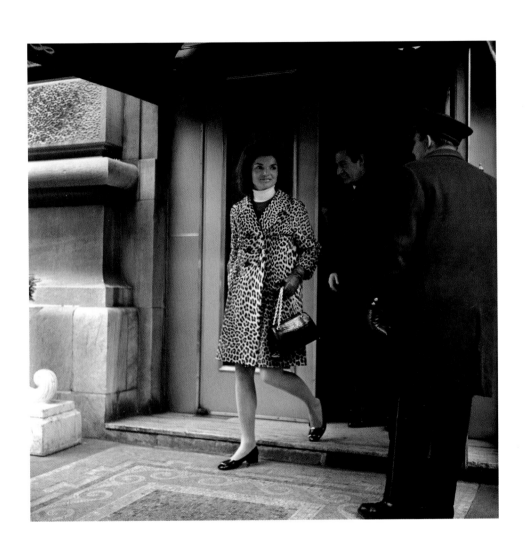

IN MANHATTAN, 1960s

ON A MANHATTAN CORNER, 1969

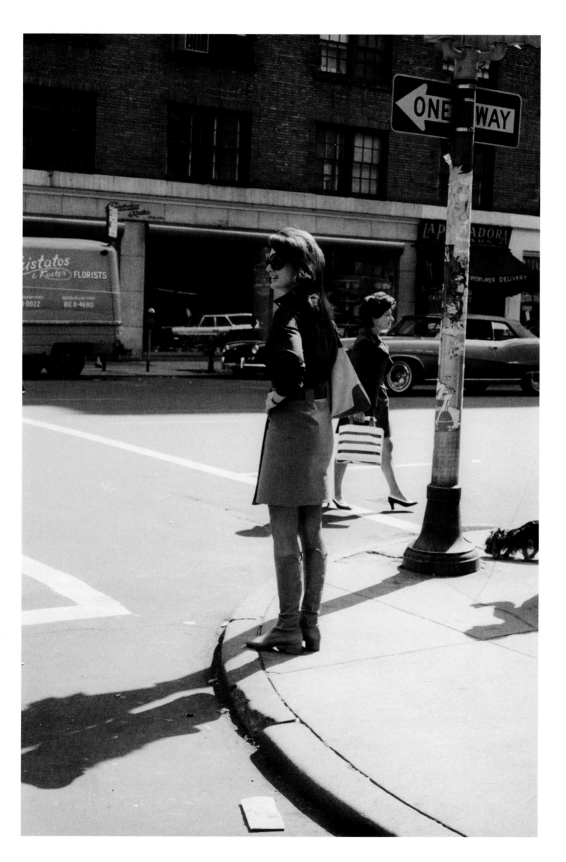

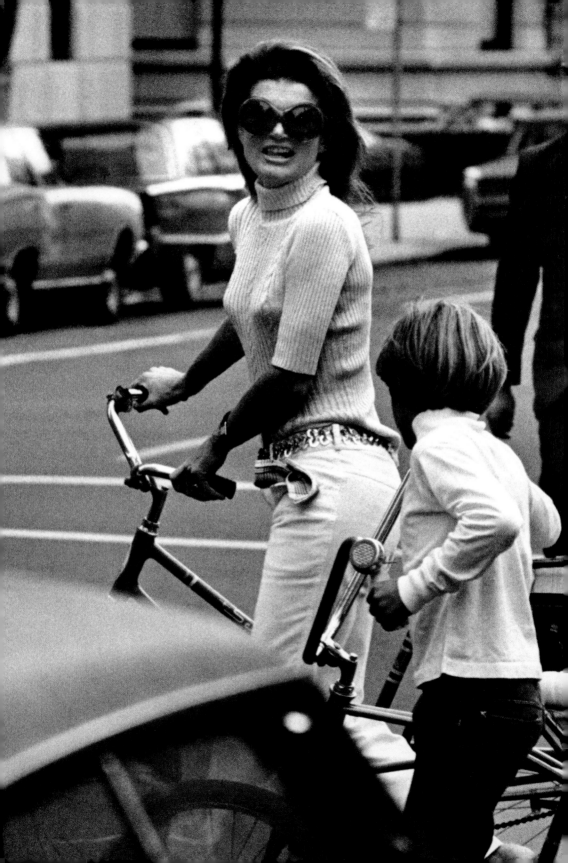

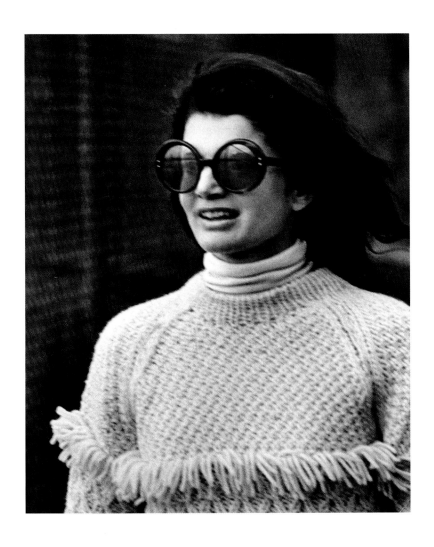

OUTSIDE LE CÔTE BASQUE RESTAURANT, 1969

< WITH JOHN JR., TAKING THEIR BIKES TO CENTRAL PARK, 1969

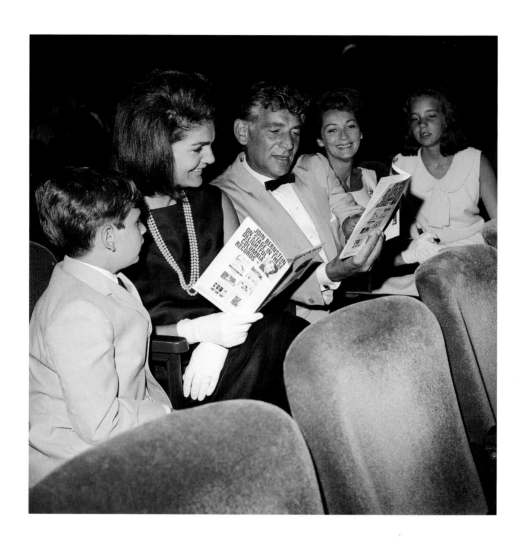

WITH LEONARD AND FELICIA BERNSTEIN AT THE THEATRE
DE LYS, ATTENDING A PERFORMANCE OF LEONARD
BERNSTEIN'S "THEATER SONGS," A REVIEW FEATURING
SONGS FROM "WEST SIDE STORY" AND OTHER SHOWS
FOR WHICH BERNSTEIN COMPOSED, 1965

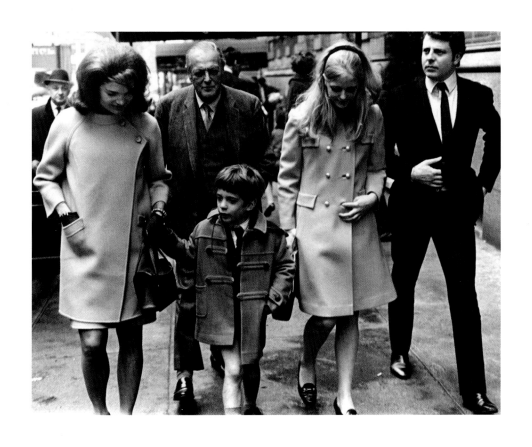

WITH RANDOLPH CHURCHILL, JOHN JR., ANNABELLA
CHURCHILL, AND ANDREW CARR, 1966

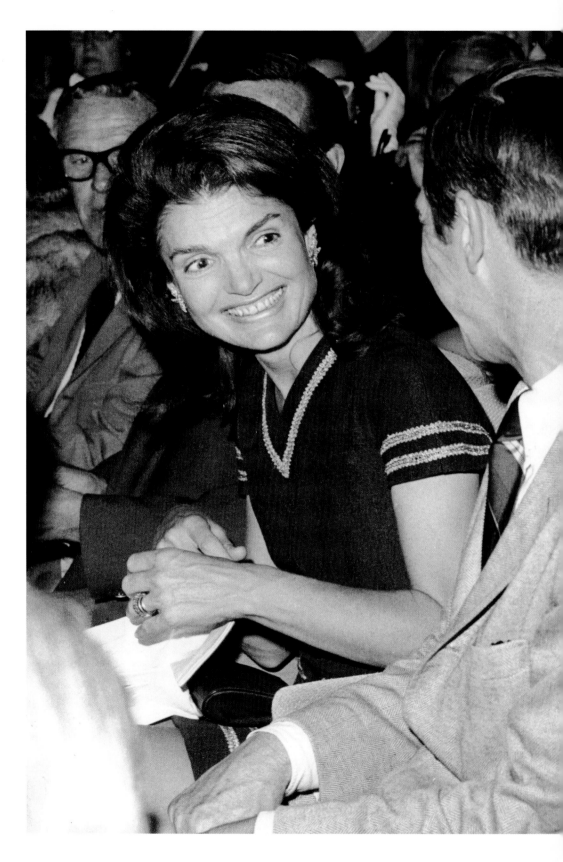

ACCOMPANYING HER HUSBAND, ARISTOTLE
ONASSIS, TO JFK AIRPORT TO SAY GOODBYE AS
HE CATCHES A FLIGHT FOR ATHENS, 1969

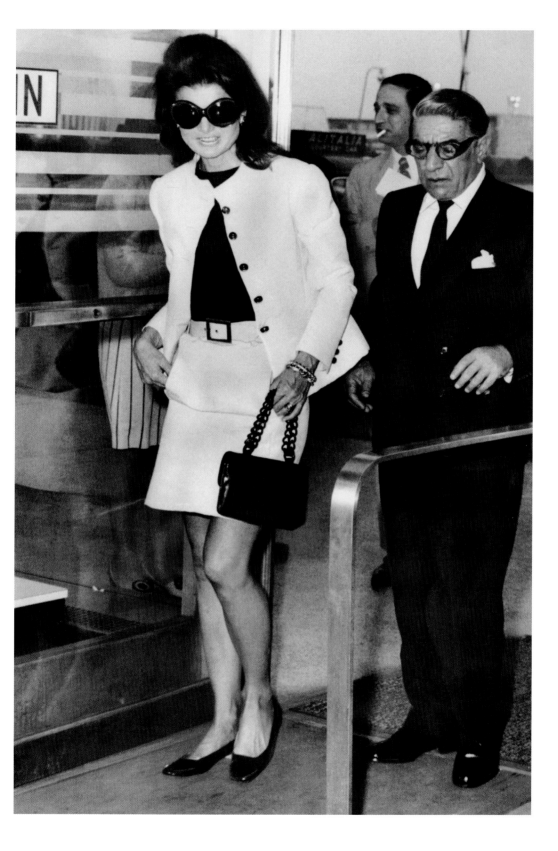

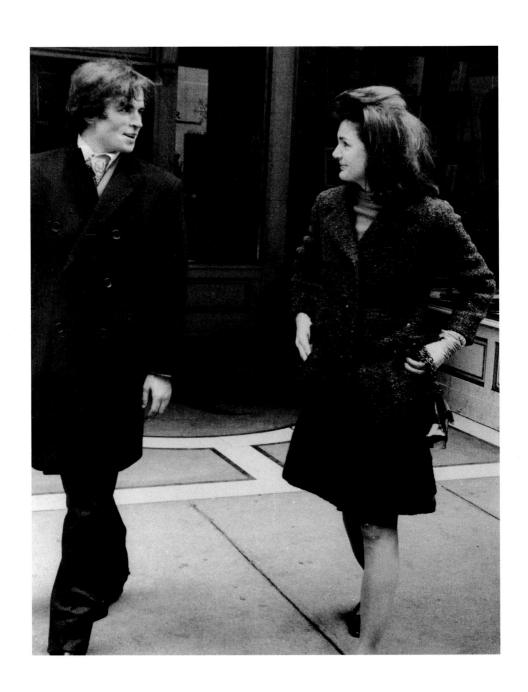

WALKING ON 5TH AVENUE WITH RUDOLPH NUREYEV, 1967

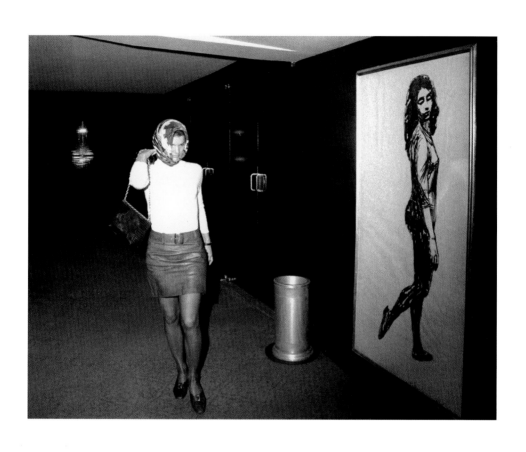

LEAVING THE CINEMA RENDEZ-VOUS AFTER
SEEING "I AM CURIOUS (YELLOW)," 1967

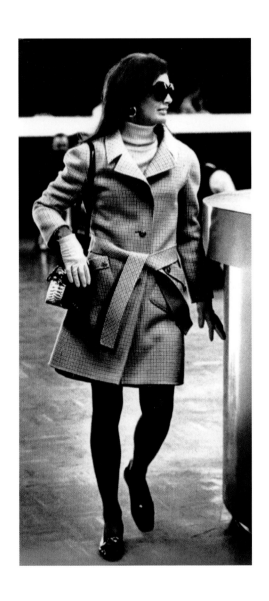

COMING HOME FROM JFK AIRPORT, 1969

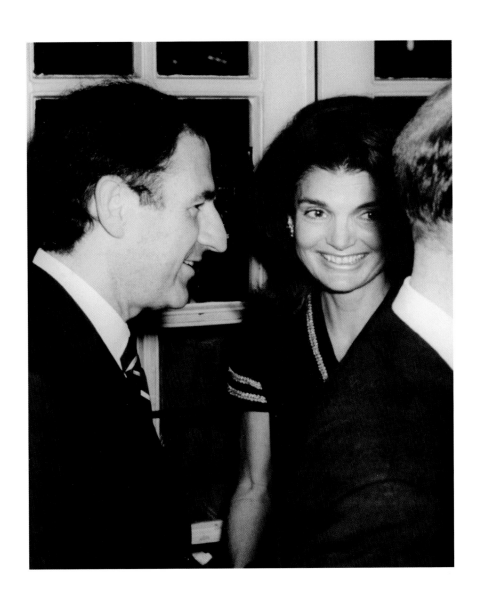

DURING THE PREMIERE OF THE PLAY "40 CARATS"
AT THE MOROSCO THEATER, 1969

WATCHING THE LIGHTING OF THE ROCKEFELLER CENTER
CHRISTMAS TREE, 1969

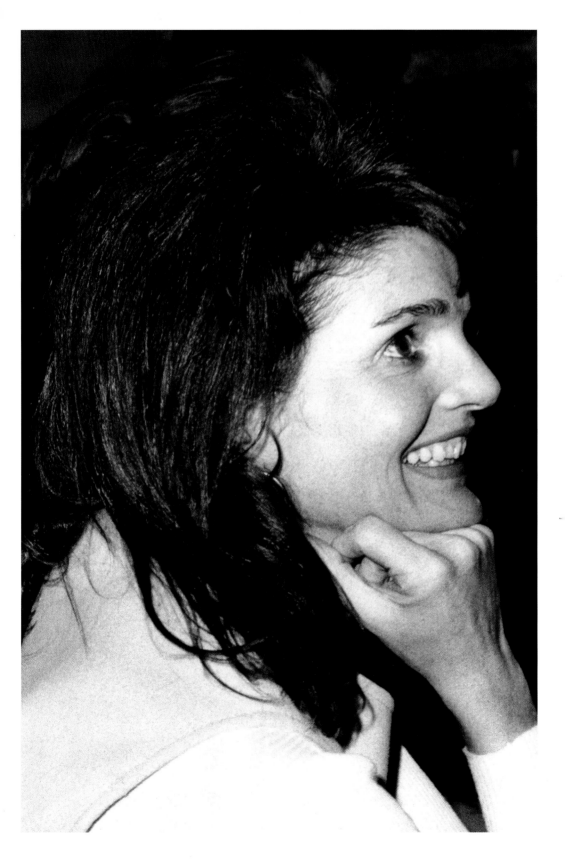

1970s

AT BONWIT TELLER, 1970

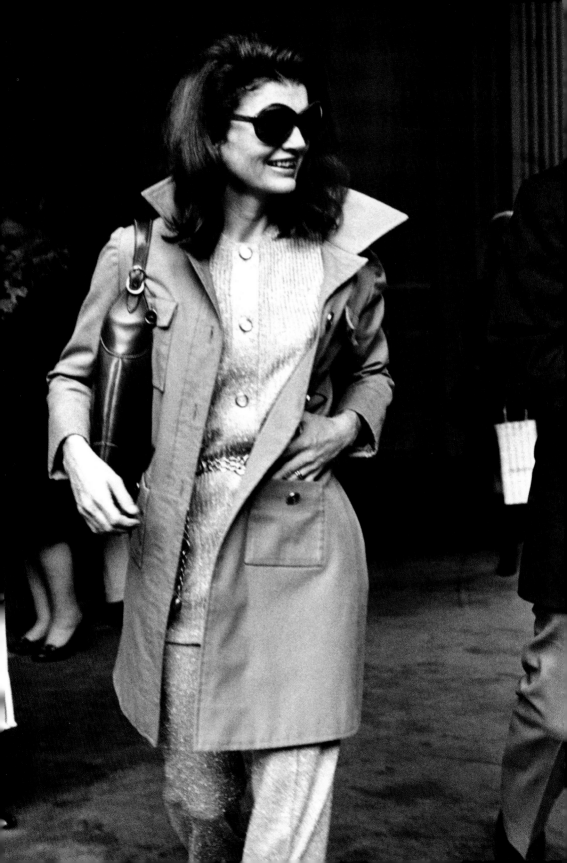

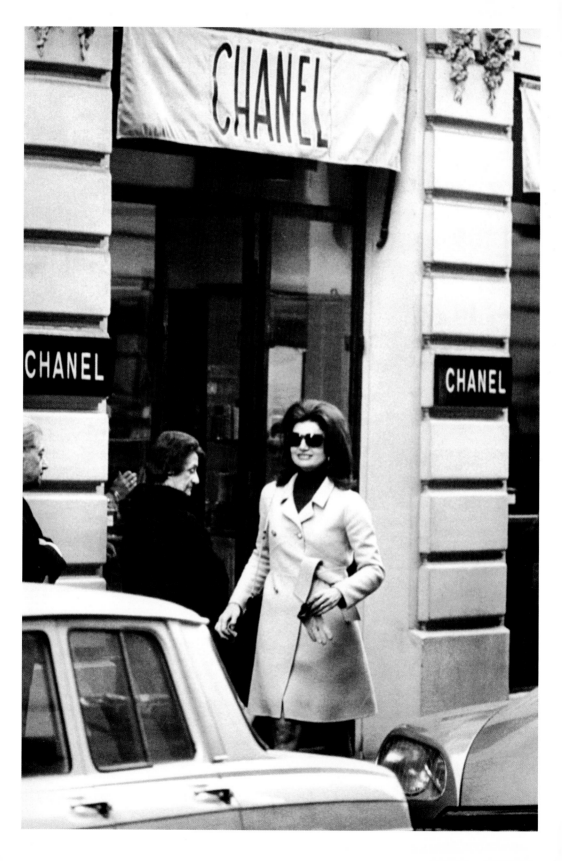

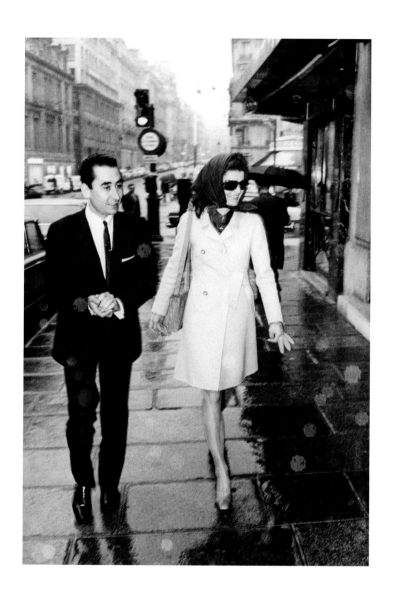

STROLLING IN THE RAIN, 1970

<OUTSIDE THE CHANEL BOUTIQUE, 1970

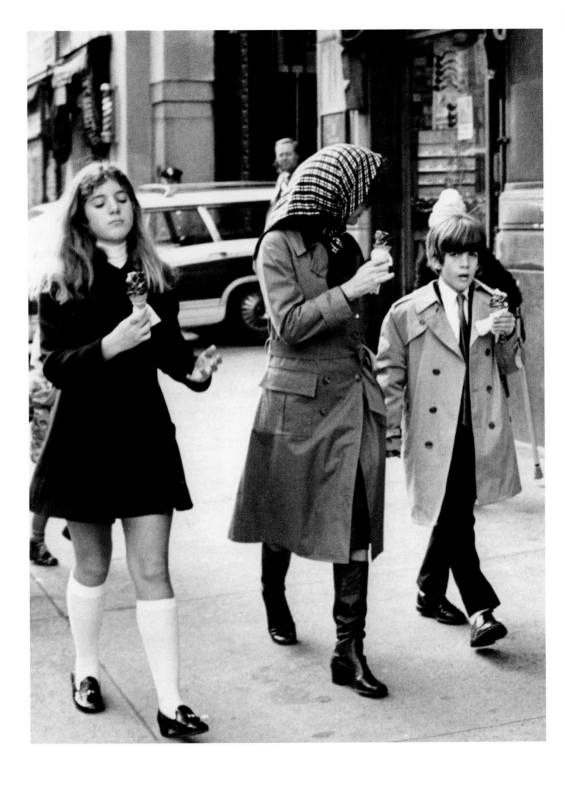

HAVING ICE CREAM WITH HER CHILDREN
AFTER A PERFORMANCE OF "HAIR," 1970

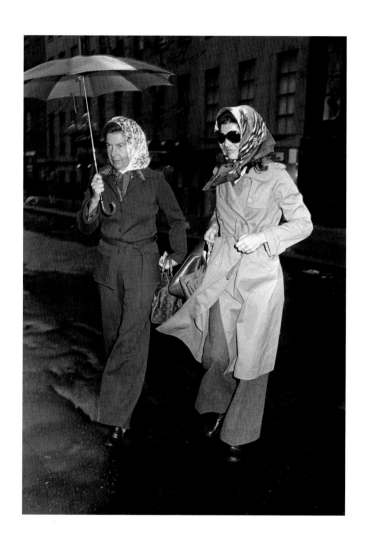

LEAVING SERENDIPITY 3 RESTAURANT, 1973

DEPARTING BONWIT TELLER, 1970

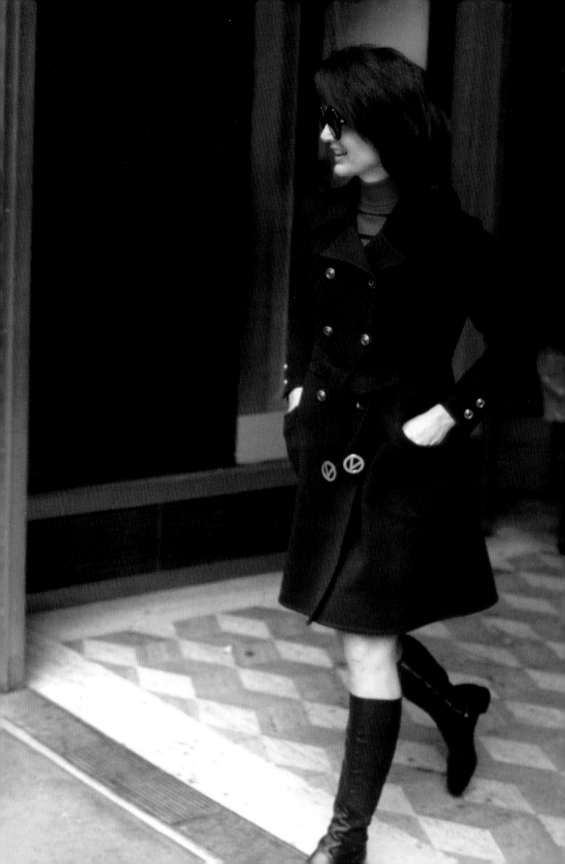

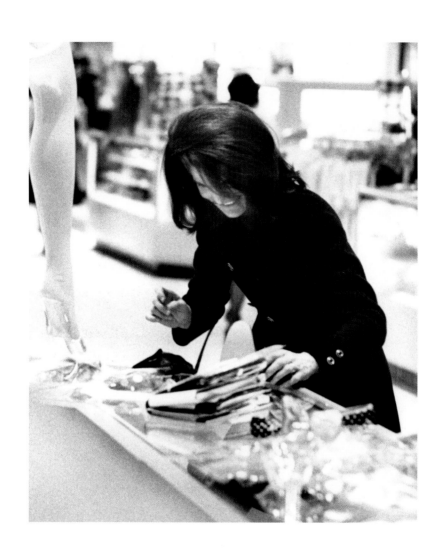

SHOPPING AT BONWIT TELLER, 1970

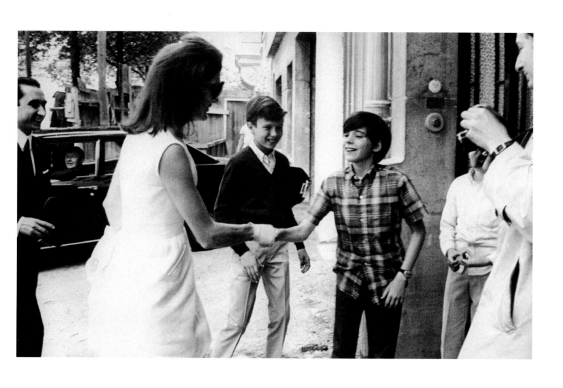

ENTERING A FRIEND'S HOME AND SHAKING HANDS
WITH ONE OF THE CHILDREN OF HER HOST, 1970

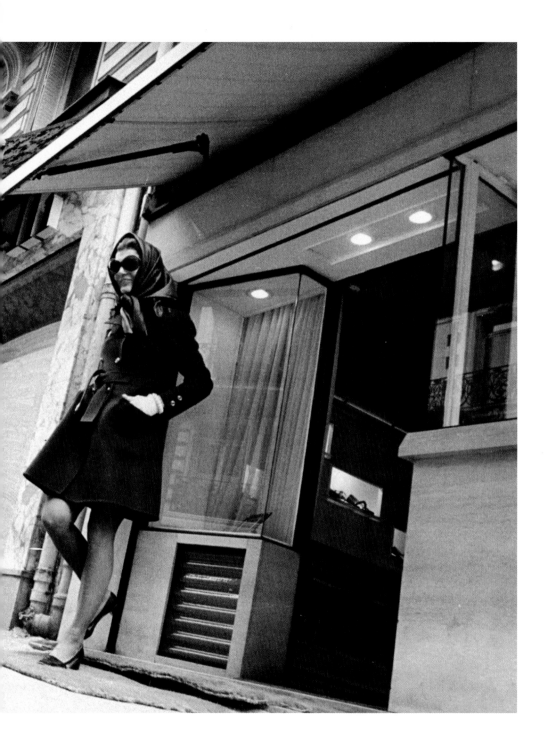

LEAVING A SHOP, 1970

IN MANHATTAN, 1970

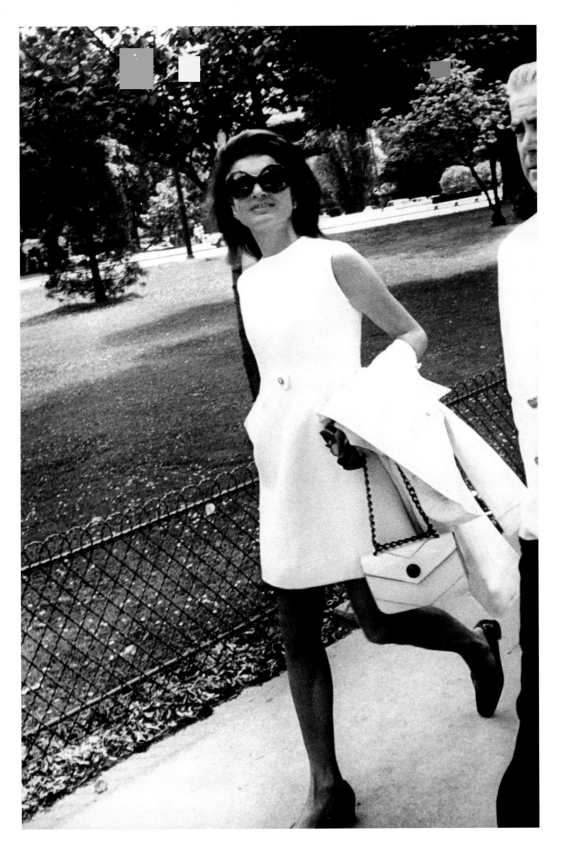

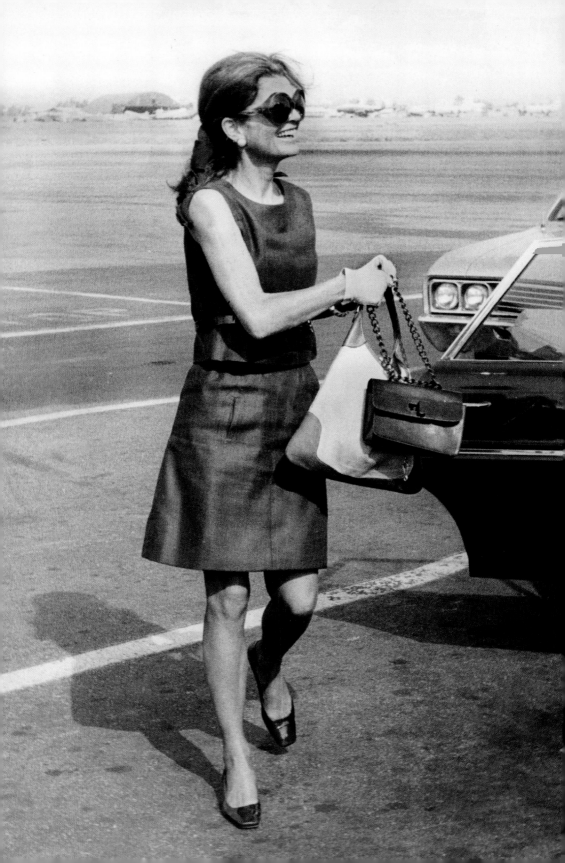

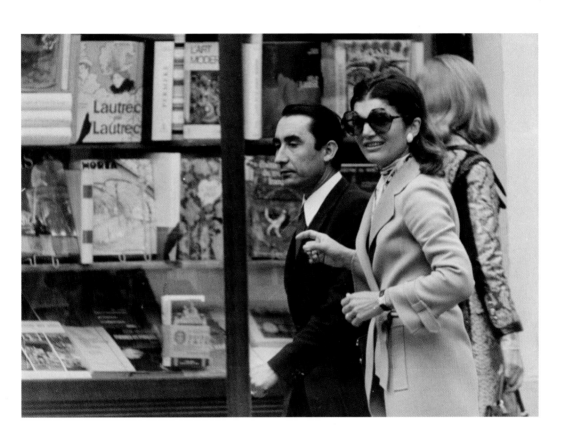

PASSING BY A BOOK SHOP, 1970

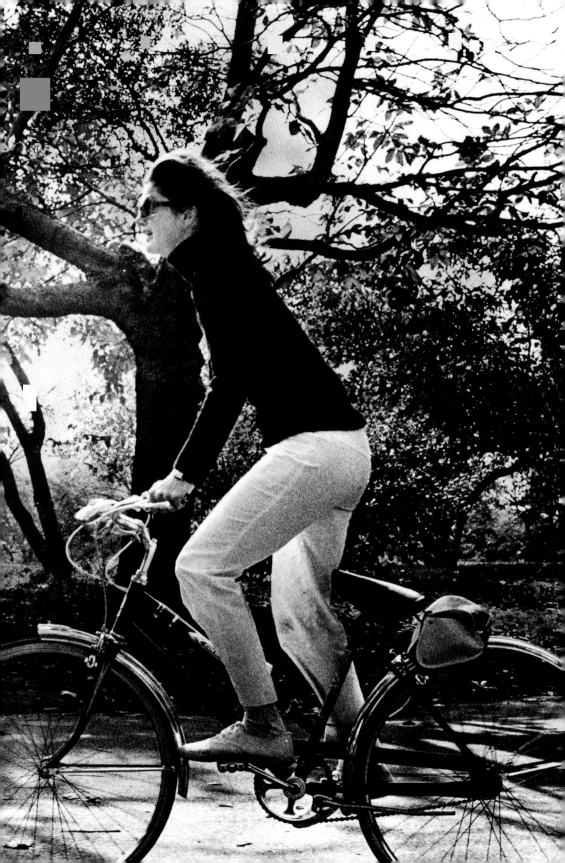

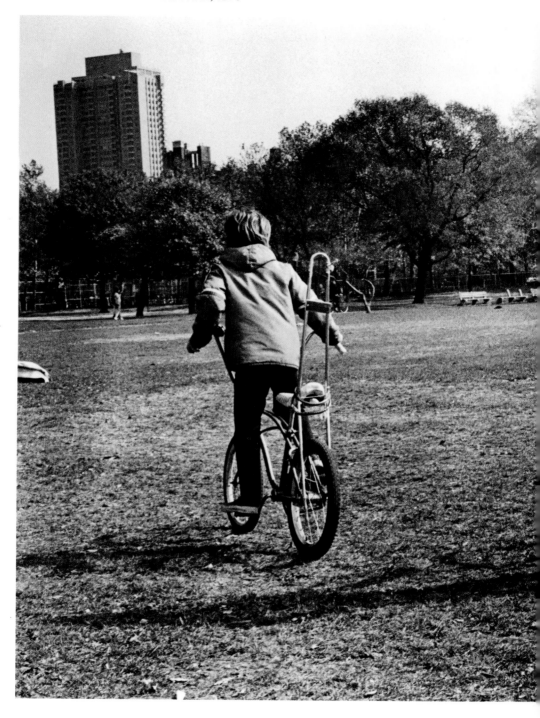

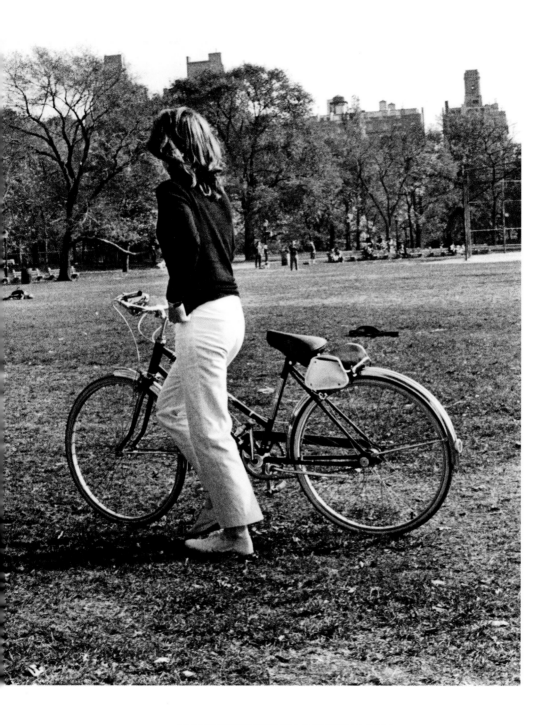

RIDING BIKES THROUGH CENTRAL PARK
WITH JOHN JR., 1970

ON MADISON AVENUE, 1971

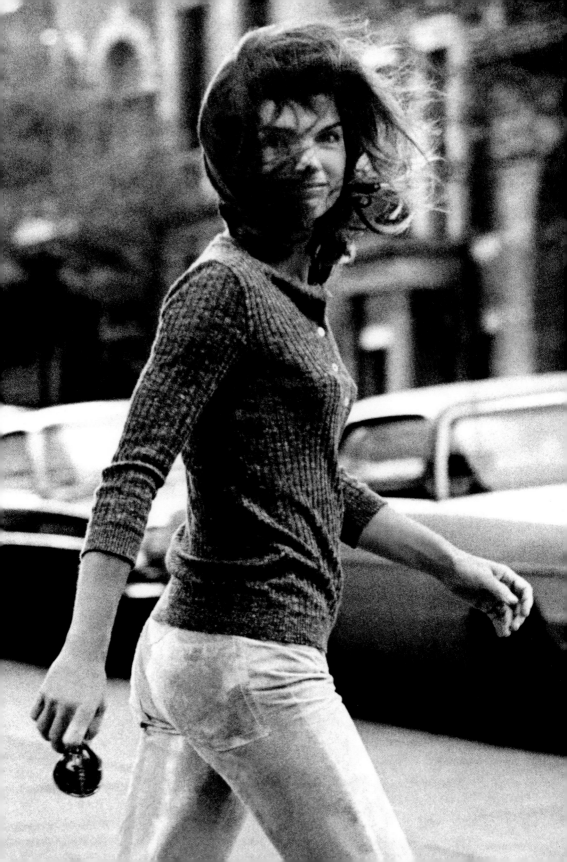

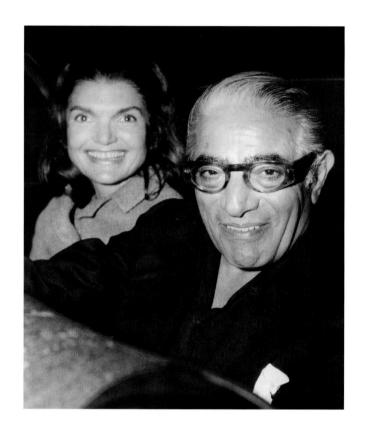

WITH ARISTOTLE ONASSIS, EARLY 1970s

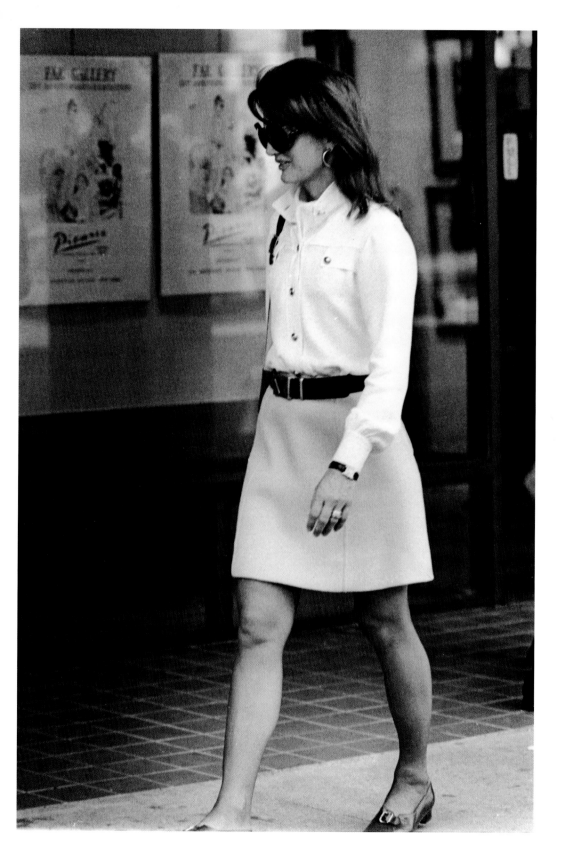

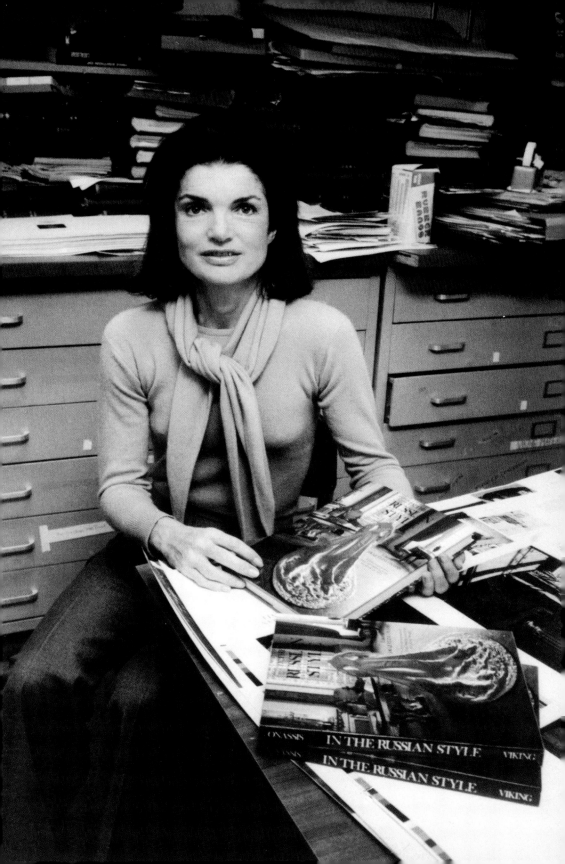

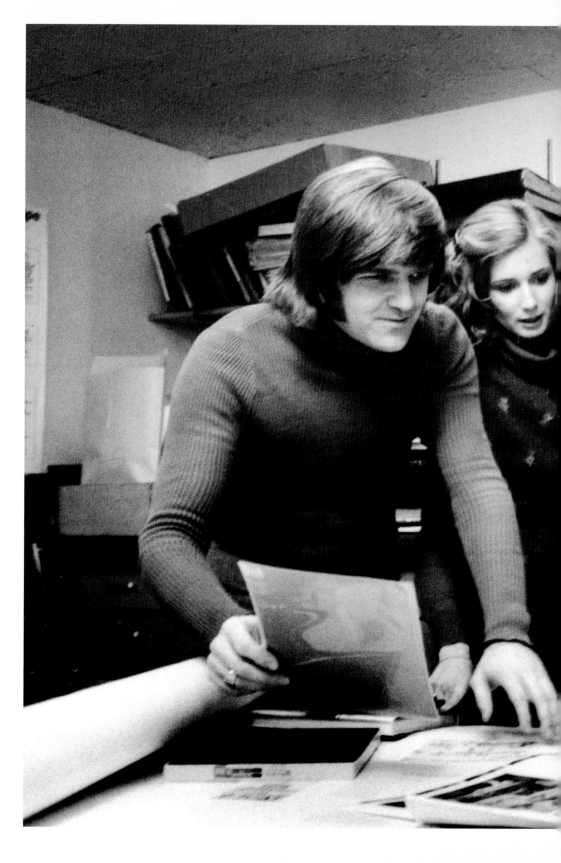

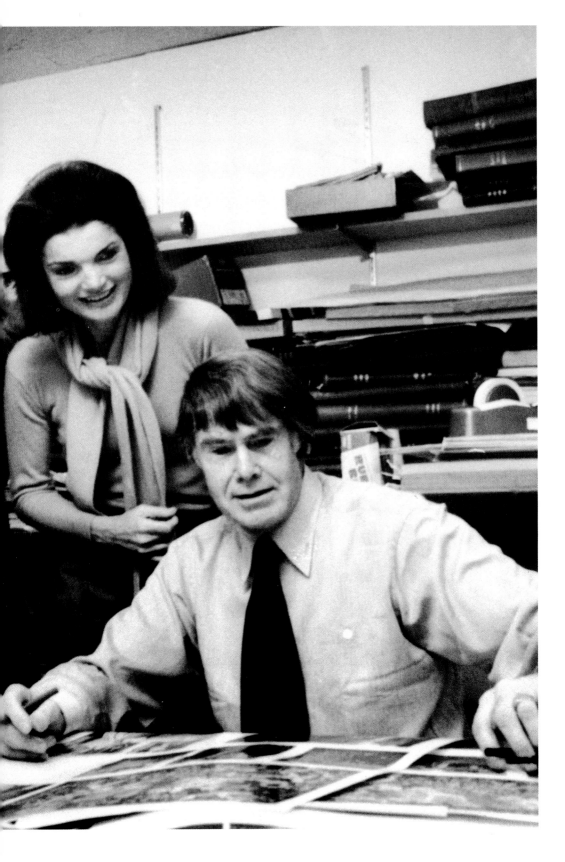

WITH ROSE KENNEDY OUTSIDE THE
METROPOLITAN MUSEUM OF ART, 1977

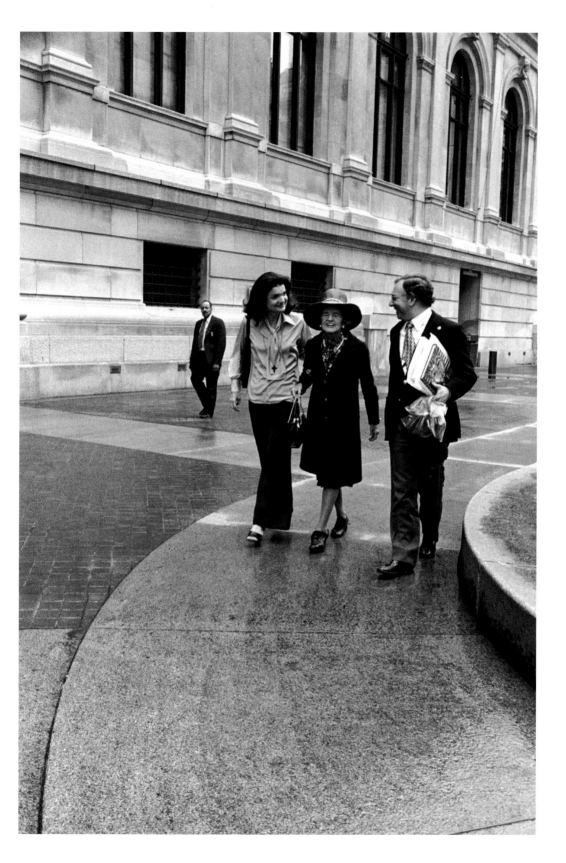

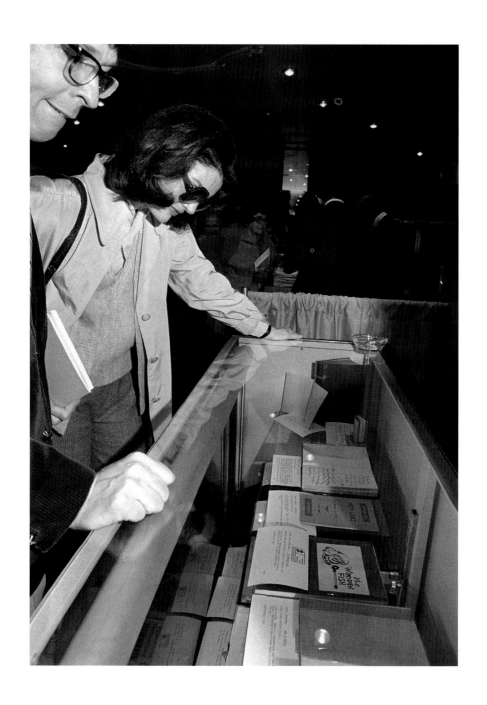

LOOKING AT BOOKS AT A BOOK FAIR
AT THE PLAZA HOTEL, 1977

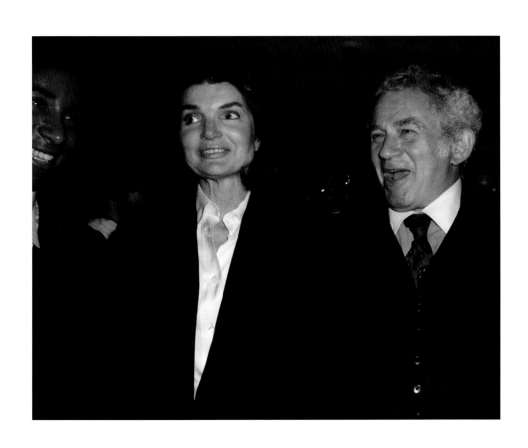

LAUGHING WITH NORMAN MAILER, 1978

IN FRONT OF GRAND CENTRAL STATION, WHICH
SHE HELPED LEAD A PRESERVATION CAMPAIGN
TO SAVE FROM DEMOLITION, 1978

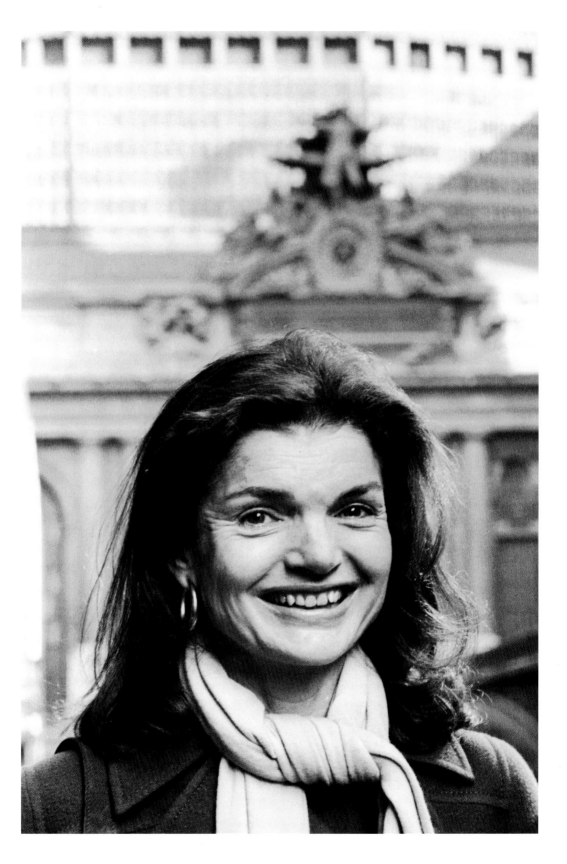

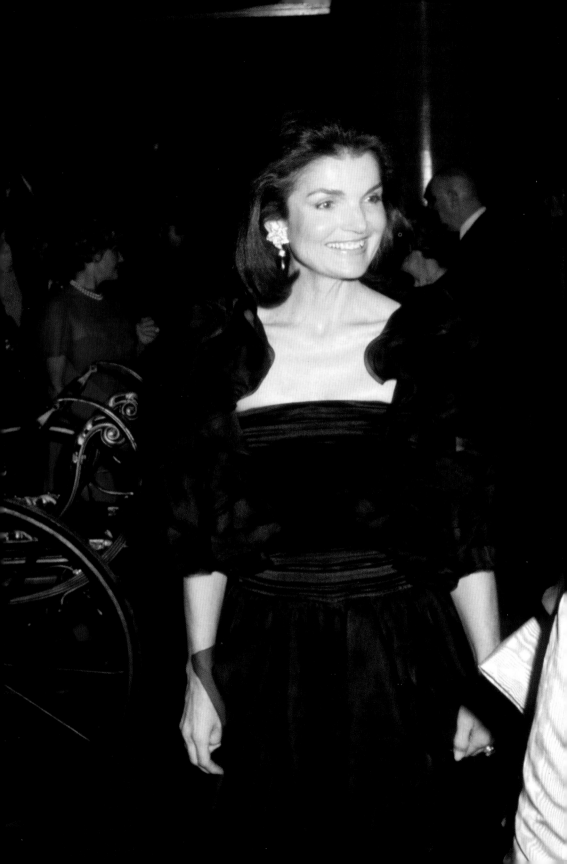

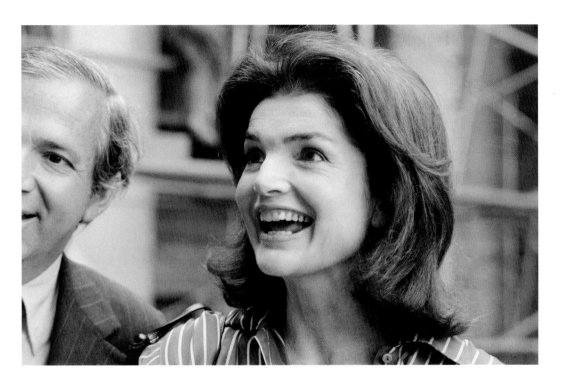

TAKING A TOUR OF THE EXTENSIVE WORK BEING
DONE BY THE MUNICIPAL ARTS SOCIETY TO RESTORE
THE HISTORIC VILLARD HOUSES BUILDING, 1979

< ATTENDING THE COSTUME INSTITUTE GALA
"FASHIONS OF THE HAPSBURG ERA" AT THE
METROPOLITAN MUSEUM OF ART, 1979

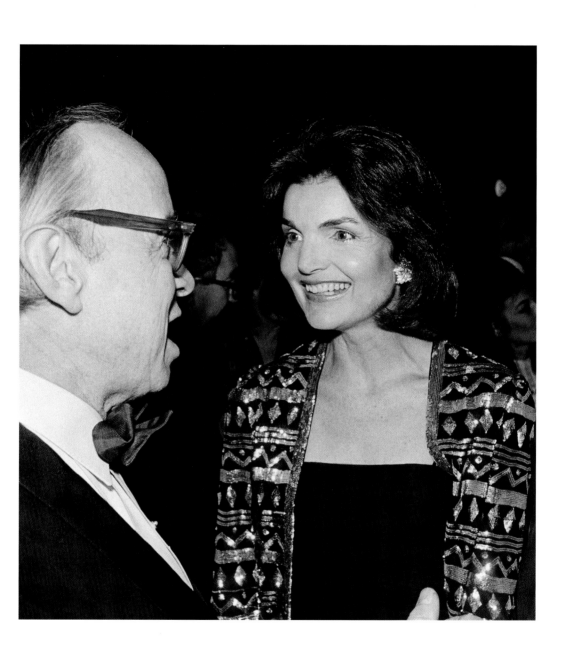

TALKING WITH ARTHUR SCHLESINGER JR.
AT A PUBLISHING PARTY, 1978

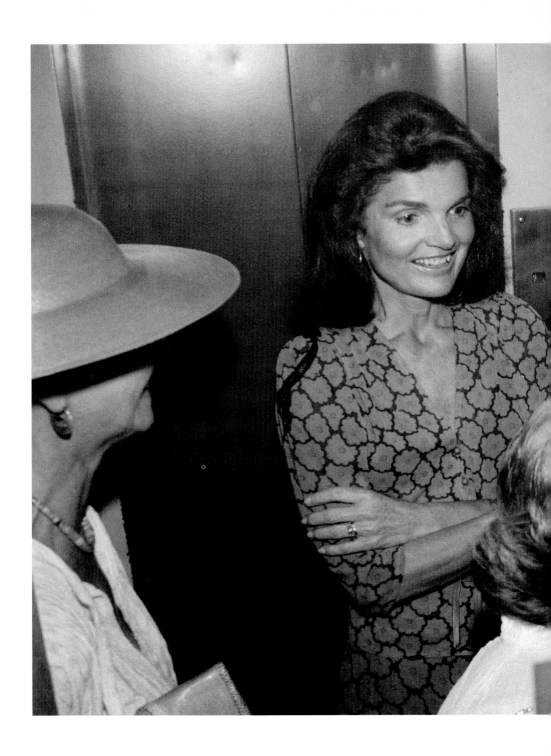

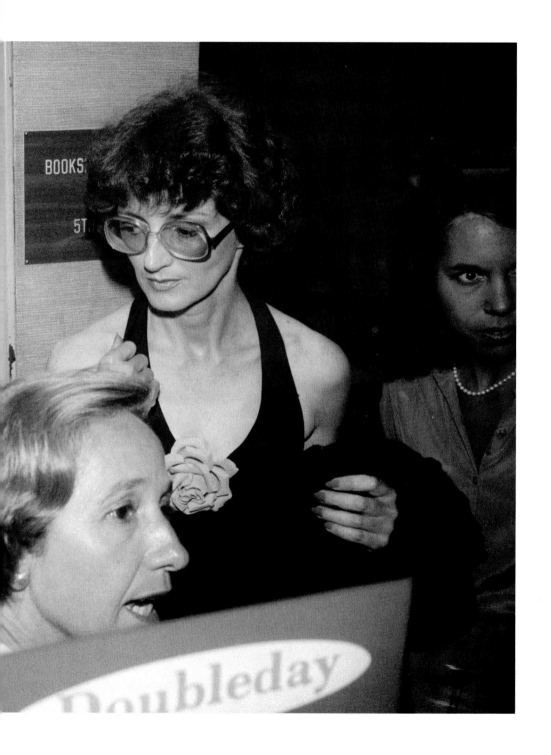

LEAVING THE OFFICES OF DOUBLEDAY BOOKS
WITH ONE OF HER AUTHORS, NANCY ZAROULIS,
AFTER A RECEPTION FOR ZAROULIS'S NEW
NOVEL "CALL THE DARKNESS LIGHT," 1979

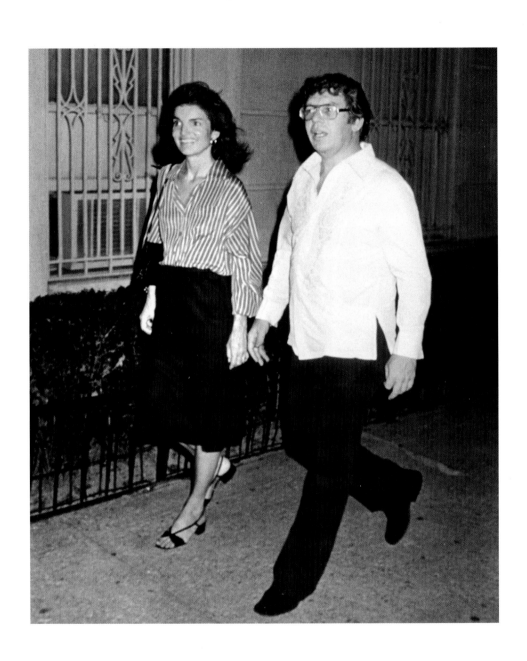

WALKING WITH PETER HAMIL ON 5TH AVENUE, 1979

IN MANHATTAN, 1979

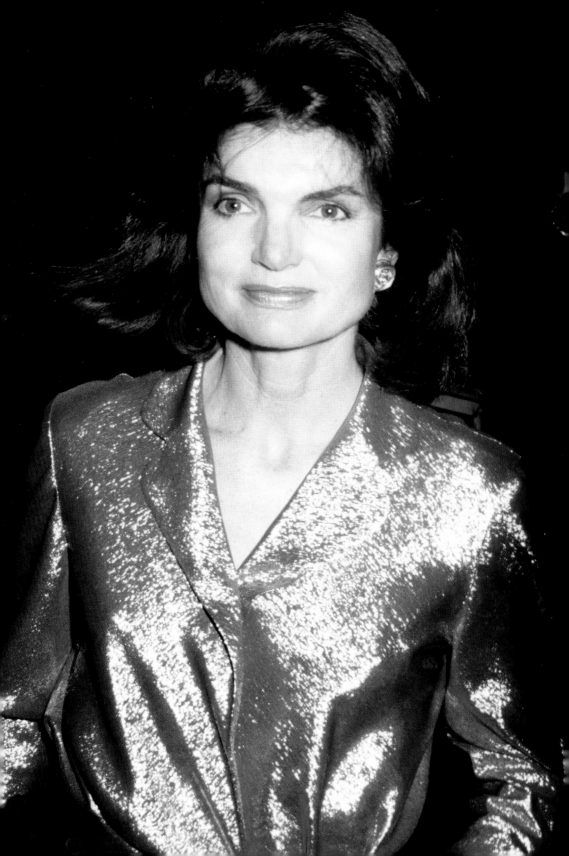

1980s

1990s

LEAVING A CINEMA, 1981

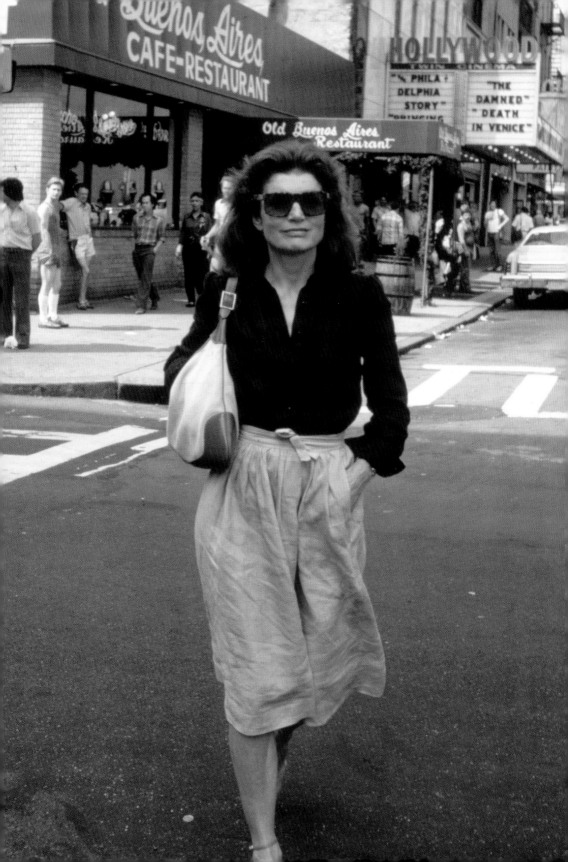

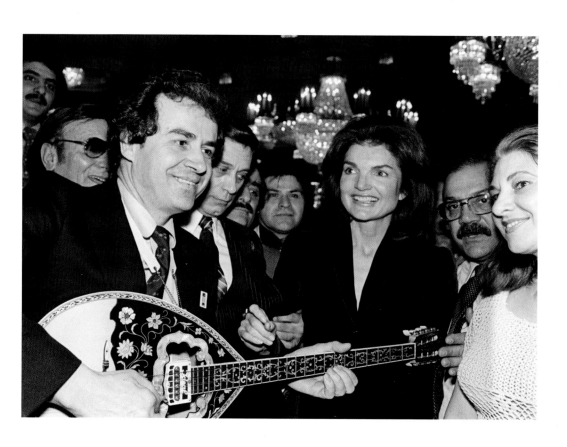

CAMPAIGNING FOR TED KENNEDY AT A GREEK
RESTAURANT IN ASTORIA, QUEENS, 1980

WALKING IN MANHATTAN ON THE FOURTH OF JULY, 1984 >

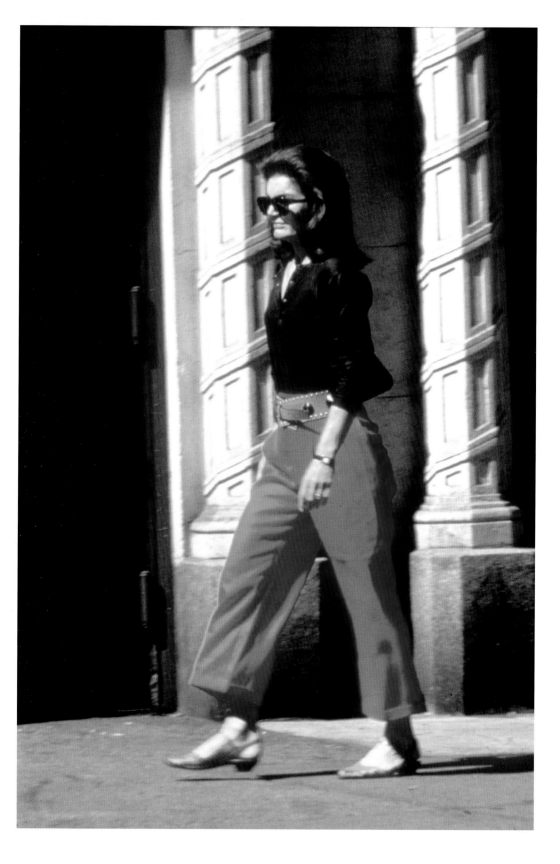

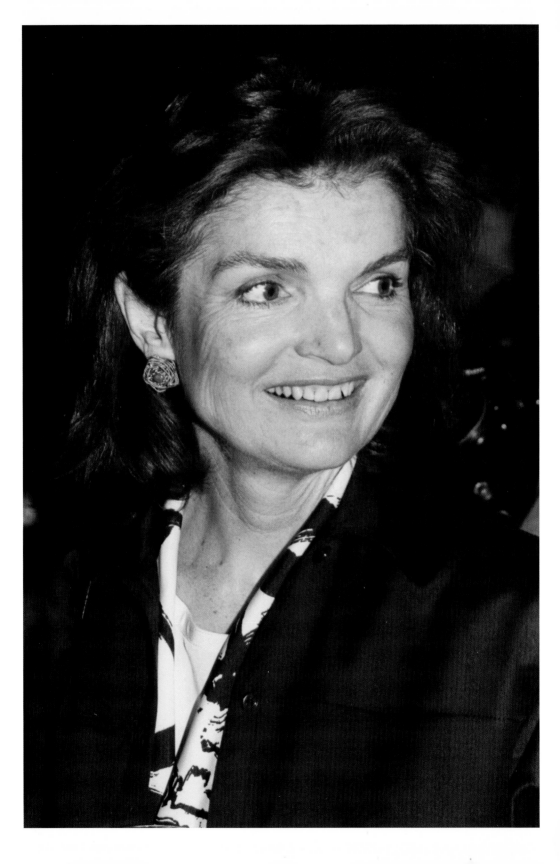

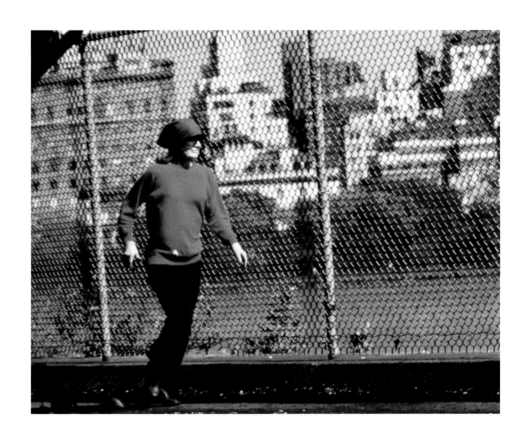

RUNNING IN CENTRAL PARK, 1984

<AT THE AMERICAN ACADEMY AND INSTITUTE OF ARTS
AND LETTERS AWARD CEREMONY, 1985

ATTENDING THE AMERICAN ACADEMY AND INSTITUTE OF
ARTS AND LETTERS AWARD CEREMONY, 1985

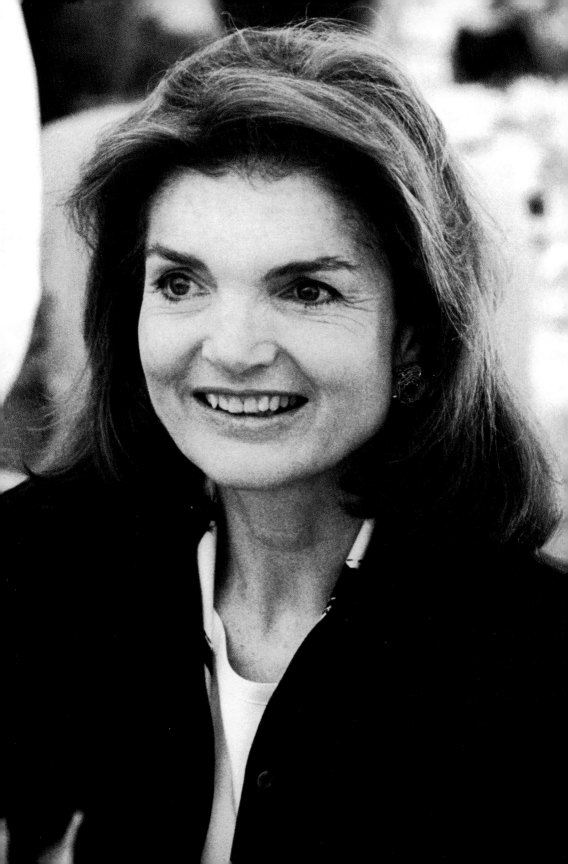

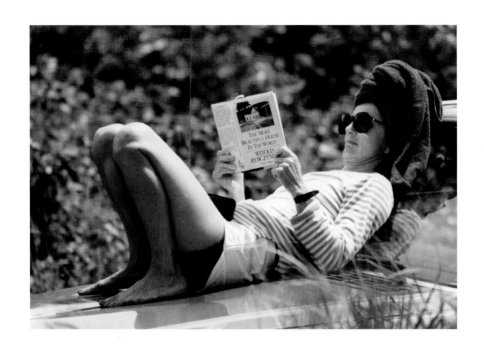

IN MARTHA'S VINEYARD ON HER
60TH BIRTHDAY, 1989

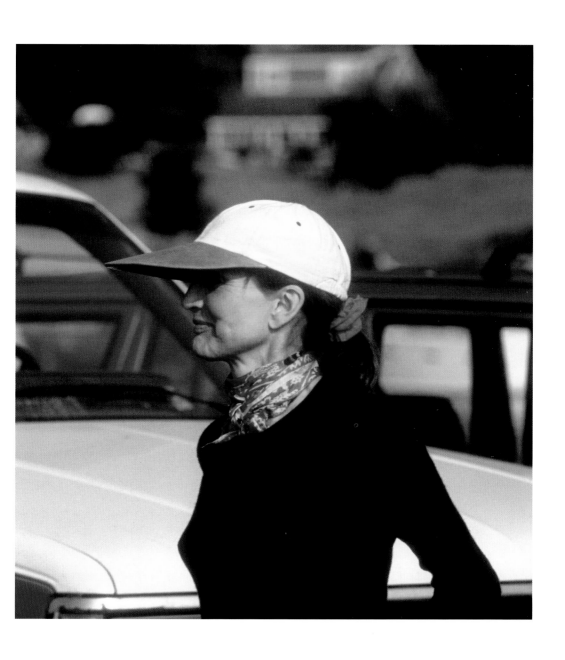

WHILE HOSTING A VACATIONING PRESIDENT CLINTON
AND FAMILY AT MARTHA'S VINEYARD, 1993

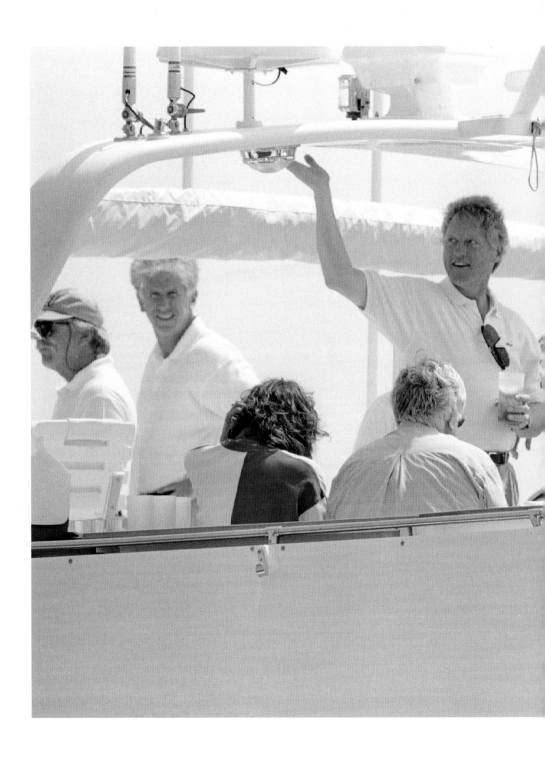

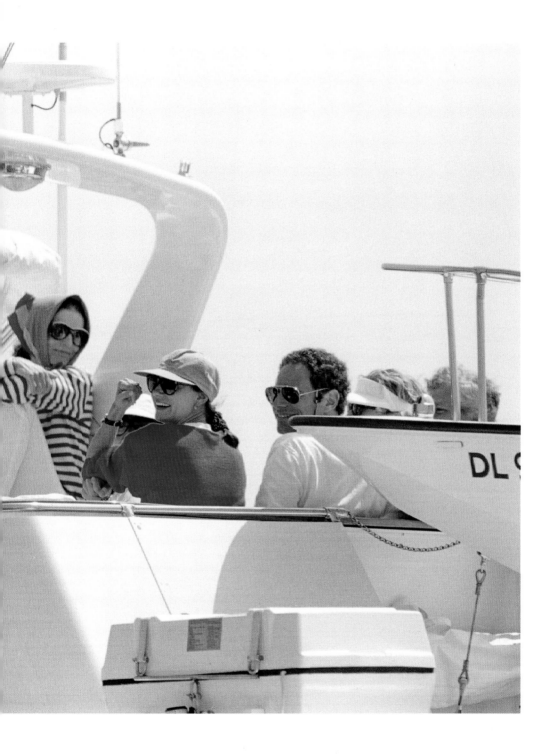

WITH VACATIONING PRESIDENT BILL CLINTON,
FIRST LADY HILLARY CLINTON, TED KENNEDY, AND
OTHER FAMILY MEMBERS ON A BOAT IN MENESHA
HARBOR AT MARTHA'S VINEYARD, 1993

AT AN ART SOCIETY MEETING IN BRYANT PARK, 1992

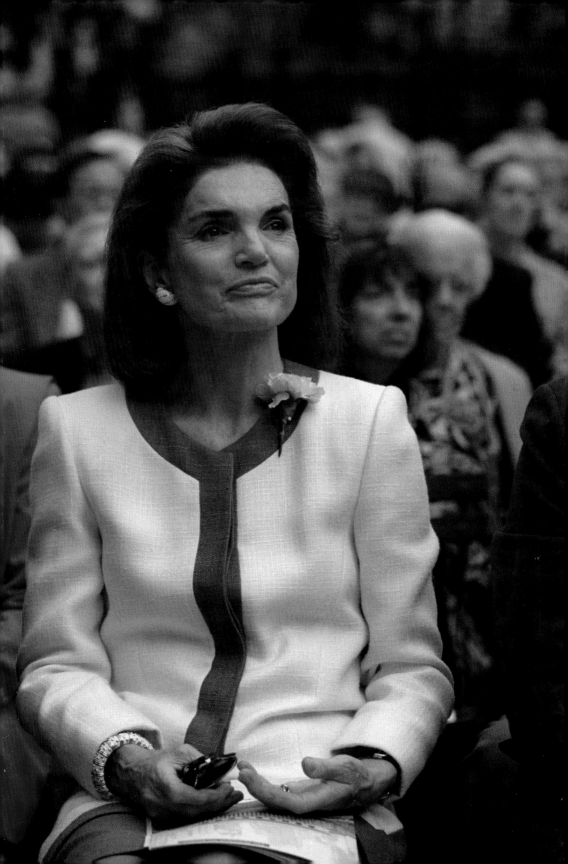

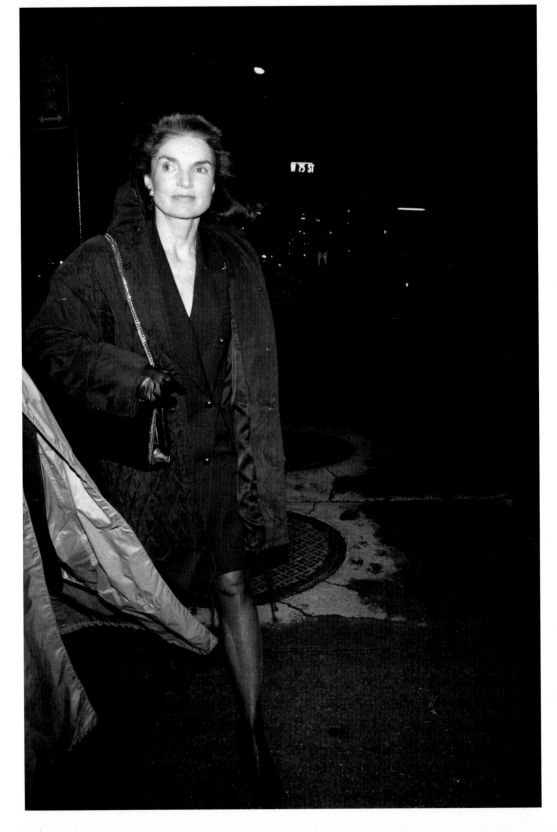

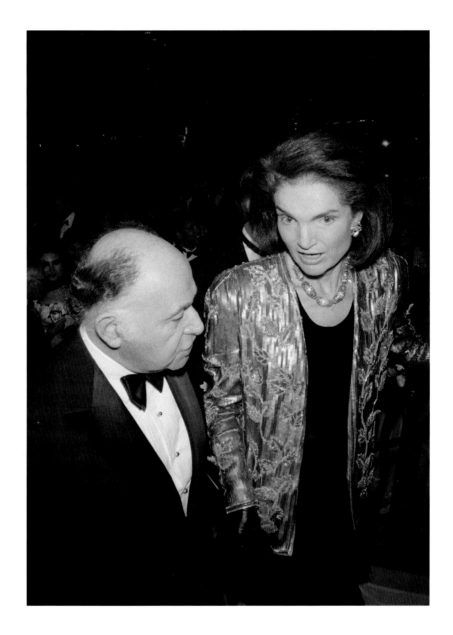

WITH MAURICE TEMPELSMAN AT A PARTY
FOR THE PREMIERE OF THE MOVIE "CLOSET
LAND" AT HENRI BENDEL, 1991

< ARRIVING AT A PUBLISHING EVENT, 1991

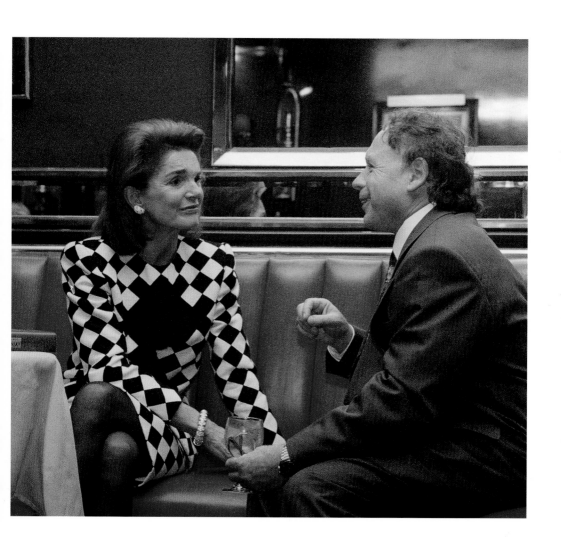

CHATTING WITH AUTHOR EDVARD RADZINSKY
DURING A RELEASE PARTY AT THE RUSSIAN TEA ROOM
FOR HIS NEW BOOK "THE LAST TSAR," WHICH SHE
ACQUIRED FOR DOUBLEDAY BOOKS, 1992

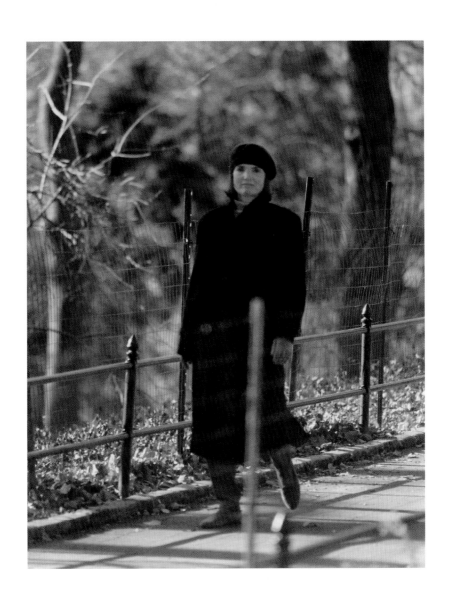

WALKING IN CENTRAL PARK, 1993

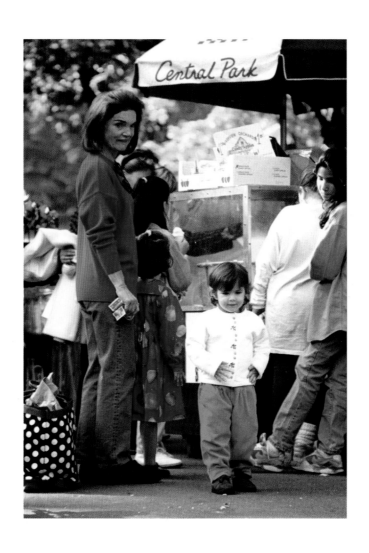

WITH HER GRANDDAUGHTER ROSE
IN CENTRAL PARK, 1992

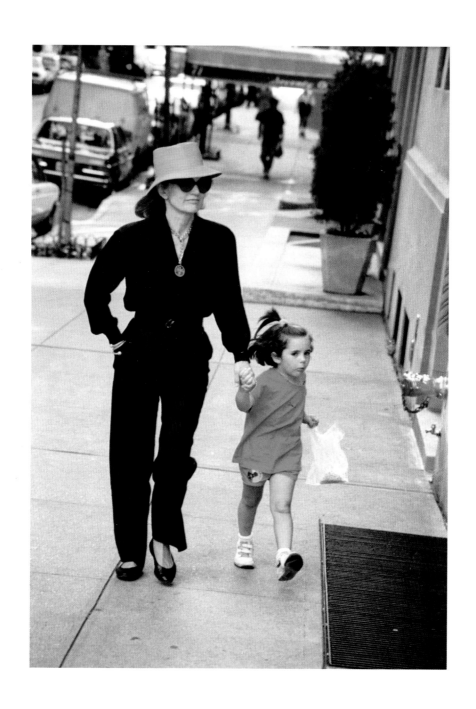

WITH HER GRANDDAUGHTER ROSE, 1992

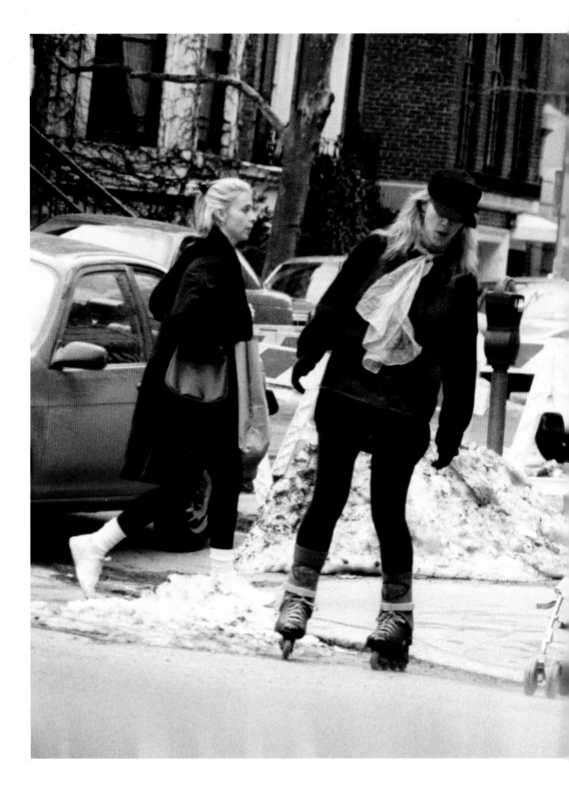

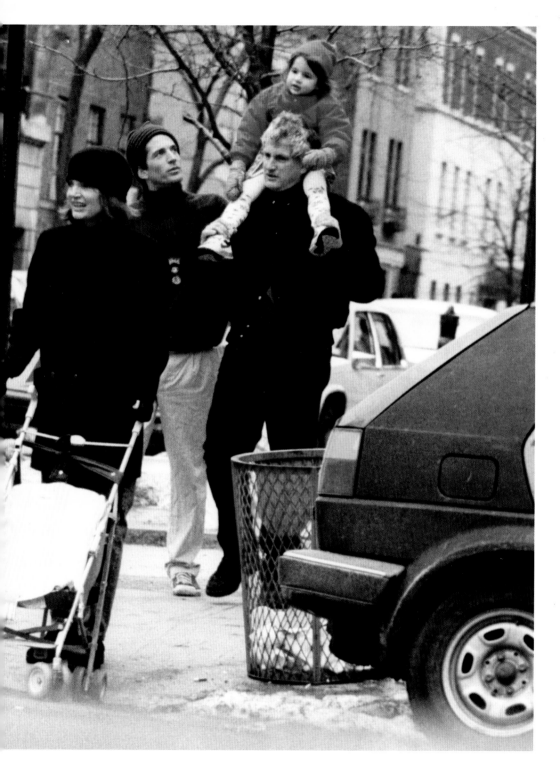

WALKING IN MANHATTAN WITH CAROLINE,
JOHN JR., EDWIN SCHLOSSBERG, AND
GRANDDAUGHTER ROSE, 1994

PHOTO CREDITS